Vacant Eden

: ROADSIDE TREASURES OF THE SONORAN DESERT

First Printing
Vacant Eden: Roadside Treasures of the Sonoran Desert
©1997 Abigail Gumbiner, Carol Hayden, and Jim Heimann

Design by Three Loop Nine Design
Imaging and production by Navigator Press
Printed in Singapore

Library of Congress Catalog Card Number: 96-078617

ISBN 0-9643119-5-X

Vacant Eden

: Roadside Treasures of the Sonoran Desert

INTRODUCTION BY
JIM HEIMANN

PHOTOGRAPHY BY
**ABIGAIL GUMBINER &
CAROL HAYDEN**

BALCONY PRESS LOS ANGELES

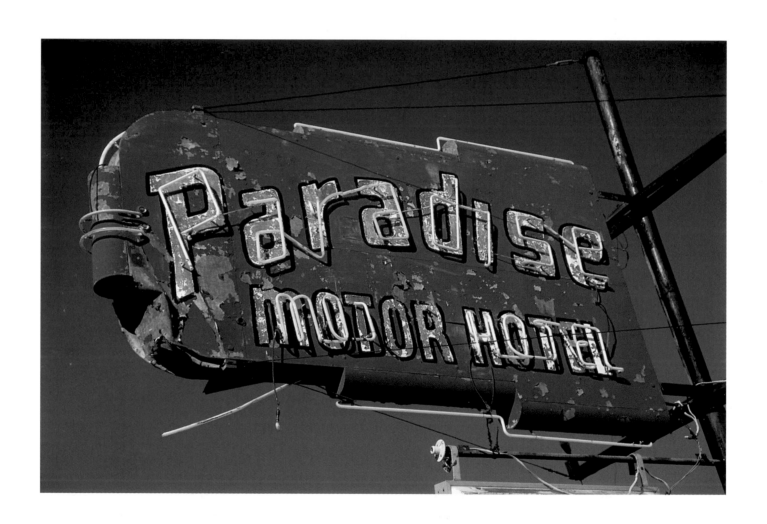

Historically, American vernacular architecture has been perceived as ephemeral, second-class in nature.

Rarely discussed by critics until the mid-20th century, its importance in architectural history has been more or less ignored. Consequently, buildings and signage which were, and continue to be, integral to American life are considered disposable, often disappearing before their importance in the culture and landscape is recognized. As these artifacts of everyday life evaporate, the recognition and visual preservation of them has fallen mostly to a handful of photographers. By choice or aesthetic, their documentation of the remnants of a swiftly disappearing America has saved an elemental aspect of the common American experience from obliteration. Nowhere has this wholesale demolition of the American experience occurred so rapidly as along the American roadside.

The American roadside, once a disjointed and sublime series of roadways, became, in its heyday from 1920 to 1960, a massive network of interconnected highways. By the end of World War I, a much traveled, informal system of thoroughfares joined rural towns to larger urban centers in a new community of auto travelers. Providing services to this mobile public was inevitable: gas stations, repair shops, restaurants, diners and auto camps began filling the byways at an enormous rate.

Businesses catering to the auto trade had to attract a potential customer's attention with advertising that addressed speed. Pedestrian traffic, once the driving force in commerce, gave way to the automobile once the car became an affordable commodity. Affordability came via the combination of installment buying and Henry Ford's assembly line, making a Model T available to most everyone by the mid-'20s. Americans hit the highway with a vengeance.

1

As a result, signs rather than window displays seduced customers off the road. Signs became larger and flashier. Buildings themselves became signs. With the introduction of neon, a new era of highway culture was born. This new breed of traveler succumbed to the lure of the road. Tourism rose to new heights. The culture of the car, fostered for three decades, accelerated with enormous speed. Drive-in theaters and restaurants, motels, tourist courts and roadside attractions unfolded along the highway. The car vacation supplanted rail as travel preference. Criss-crossing the U.S. in an automobile made travel possible for almost everyone: destinations once reserved for the privileged now could be visited by Mom, Pop, and the kids.

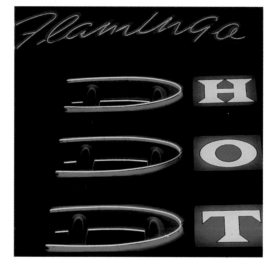

The glory years of the roadside continued until the Depression cut into pleasure travel for most Americans, while the southwestern highway remained the domain of truckers and Dust Bowl immigrants. Wholesale travel, however, continued to gain momentum in the late '30s and up to the United States' involvement in World War II. The wartime halt in auto production and the implementation of gas rationing ended, for the duration, the use of the car as a leisure vehicle. World War II was, paradoxically, responsible for a rise in roadside buildup, due to an influx of military personnel into the Tucson area. Motels, gas stations, and cafès quickly sprang up along Highway 89 on the north and Benson Highway at the city's southern entry. Even before the war, such cultural artifacts—as we see them now—were threatened: the problems of a cluttered and dangerous highway system were beginning to be addressed. The concept of controlled and limited-access roads was proposed, an idea which would eventually lead to the Interstate Highway System and the National Highway Act of 1956. The Act paved the way for interstates, effectively eliminating the old commercial strips. Nonstop travel and off-ramps led to an almost immediate decline of the once thriving commercial culture, along with the coming of affordable jet travel not long afterward. The living legacy of the moribund late twentieth-century roadside was a collection of offroad artifacts, abandoned and ripe for demolition. But at the end of the war, a decade earlier, America picked up where it

had left off. Flush with jobs, new families and the G.I. Bill, millions of travelers struck out for the open road. The imagery that enticed travelers and provided an informal marketing strategy for most of these roadside businesses was a conscious response to regional preferences. An outdoor advertising program depended on reinforcing actual and perceived elements of a given region. Consequently, a visual discourse was initiated between building and customer, selling image over content as an inducement to try the product. In the Southwest, the image was that of the "Wild West".

The real "Wild West" was not a canned concept, but a drive to exploit the economic possibilities of a vast frontier, resulting in a real-life struggle by Native Americans, Spaniards, Mexicans, and Anglos—a struggle for survival. The actual history served as an iconographic base shaping the images presented to visitors and tourists. The idea of the West became preeminent when the real West had exhausted its supply of cowboys, Native Americans, gunfights and wagon trains. By the early 1900s, a Wild West conjured by pulp writers and tourist-brochure descriptions had become a fictional

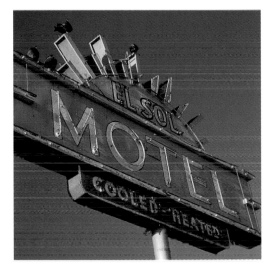

truth. When applied to motel signs, drive-in theaters, gas stations and other commercial enterprises, the new West was realized. Part fact. Part fiction.

In creating this illusion, a fundamental ploy of advertising, travelers were served a liberal dose of mythology. Western imagery in the American Southwest was instrumental in convincing travelers to choose one business over another. Who, after eight hours' driving though the searing Arizona desert, could resist a night's lodging in the Ghost Ranch, the Bucking Bronc, or the Apache Tears?

The springboard for many of the designs is rooted in the sign-painters' tradition from the first half of this century. The same principles which served to draw in retail customers were applied to the roadside, though on a larger scale. Combined with the new medium of neon for added highway impact, they set themselves apart in a new category: advertising art. Their designs, traceable stylistically decade by decade, began with type and figurative imagery, evolving into post-war boomerangs and palette shapes. In between were all the familiar attention-getting devices for travelers

passing by at 35 mph. Arrows, stars, zigzags. Type styles were a hodgepodge. Sans serif and sexy script. Novelty fonts evoking old wooden hand-set type or vaguely "Indian" lettering, a choppy Pueblo style suggesting native American handiwork.

The evolution of the American roadside served as a template for Tucson's own roadside culture. The era which produced most of the area's roadside artifacts was heralded by the post-war boom. Before that, travel to the Sonoran desert in the '20s and '30s depended on auto patrons seeking the area's dude ranches, agricultural and mining concerns and access to Mexico via Nogales. Eclipsed by Phoenix, the state's capital, and too far south of the heavily traveled Route 66, Tucson tourism was less demanding and the minimal facilities of several downtown hotels easily accommodated temporary visitors.

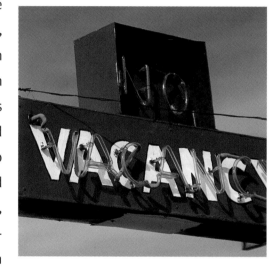

The end of the war signaled renewed prosperity. Americans lured by new cars and cheap gas took to the road in massive numbers. Tucson, flooded with newcomers, spread east and north. Commercial buildings sprang up overnight. An increasing number of motels crowded main arteries leading in and out of town, followed by a rich assortment of ancillary services. This became the heart of what a scant forty years later would be abandoned to low-income snowbirds, itinerants and urban renewal—and the subject of this photographic study.

Driving through modern-day Tucson, one feels a pervasive connection to the city's former self. Though condominiums and shopping malls congregate amidst the saguaro, this desert town retains elements of its two-century history almost everywhere. A town bypassed and off the beaten track of Arizona tourism and commerce, its inadvertent isolation has allowed its recent past to dissipate at an informal rate, preserving many mid-century icons that have disappeared in other places throughout the West. Adobes and Victorians still stand at the city core while the outskirts are an endless blur of late-twentieth century sprawl. Yet, interspersed along dispossessed strips that once thrived as tourist and trucking corridors are the remnants of the auto culture dating to before the intrusion of interstates and the always predictable franchises.

These forgotten motels, restaurants, tourist courts, and bars are the vague reminders of a mobile America, stubbornly surviving under blue desert skies. Photographers Abigail Gumbiner and Carol Hayden encountered the last ties to Tucson's abandoned roadside along these routes. The signs which advertised many of these establishments first caught their interest. The advertising beacons which had once dominated the highway were now lone graphic survivors along a visually blighted strip. With practiced eyes, they isolated the essence of several, which quickly led them, after their initial investigation, to other old approaches to the city. There they found more surviving businesses. A rich vein of vernacular gems was soon revealed amidst Tucson's clutter.

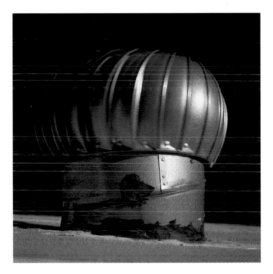

Closer scrutiny of the subjects exposed abstract studies of color and composition. Though delineating a familiar sense of the past, the photographs revealed more in their images than mere nostalgia. The history of the roadside is still evident in Gumbiner and Hayden's photographs. But, in supplying the viewer with historical documents, the photos also provide a slice of reality served with a side of longing to view some of these eroded signboards in their original, deluxe state. Even in their rusted, repaired, or overpainted condition, the signs, furniture and buildings exhibit resilience and pride. Isolation and loneliness pervade many of the images. Vacations past. Dried-up swimming pools. Abandoned ramadas. They bide their time out in the desert, temporarily down on their luck or waiting for the inevitable. Fresh coats of paint and carefully maintained grounds tell us of stubborn survival. The photographs reinstate their dignity.

The unmistakable sun of southern Arizona provides each frame with a saturating bath of dawn or sunset light, intensifying the primary colors which already predominate in the commercial architecture of the place. The intense light provides a unique clarity characteristic of the desert landscape. It furnishes the sharp blue skies and perfect clouds that appear in most every frame. Taut celadon holding swamp coolers in place. Elongated shadows of neon tubes casting added dimension on peeling enamel.

The architectural subtext of the roadside is unavoidable when considering the subject of motels and their environments. Here, the tendency of the architecture to dominate the composition is deferred, in the photos, to a subtle presence. Details delineate decades. Glass block, Spanish tile, streamlined portholes, handpainted folk flowers and Vegas-style stars assign an age for each building. Completing the exterior language are the accompanying signs with their names and images, the real allure of roadside enterprises.

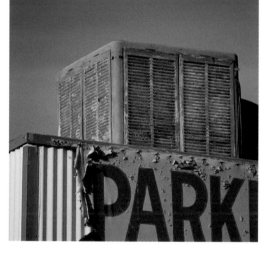

The signage hails from a time when the only way to beckon customers speeding by was to hit them between the eyes with neon glow. The golden age of sign-making produced an infinite number of static, blinking, pulsating and jerkily moving confections. Some still perform. Most don't.

The region's visual preferences—sunsets, cacti, cattle round-ups, Apaches and pueblos, suggesting Tucson's qualities, attraction and history—are shot with age and patina intact. Broken neon, faded letters and missing metal still manage to conjure romantic visions and unfulfilled adventures. The Monterey, El Sol, Desert Edge, Flamingo, Sahara, Riviera, and Paradise. The photographs capture it all.

Assessing the remnants of the recent past is not a new phenomenon. Each generation observes and preserves its collective memory in numerous ways. The photographers in this visual investigation have recorded the passing of one aspect of popular culture while addressing an issue of larger proportions.

Their observations of the stamina of the obscure, made in the context of fine-art photography, have made the subject accessible to an audience blinded by progress and development. This is a document of time and place serving notice to the ignorant that, by destroying the common objects of a shared history, an understanding of the future becomes a clouded proposition. With paradise lost, we may all be faced with vacant Edens.

Jim Heimann
January, 1997

6

Plates

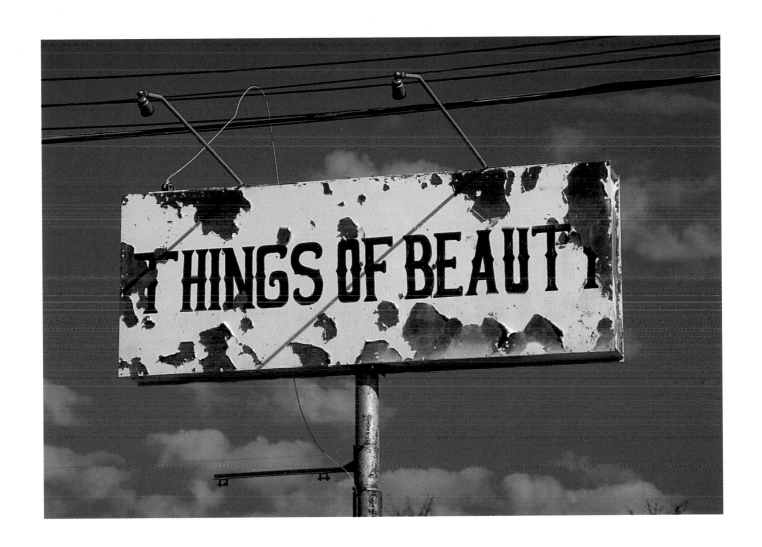

plate 1

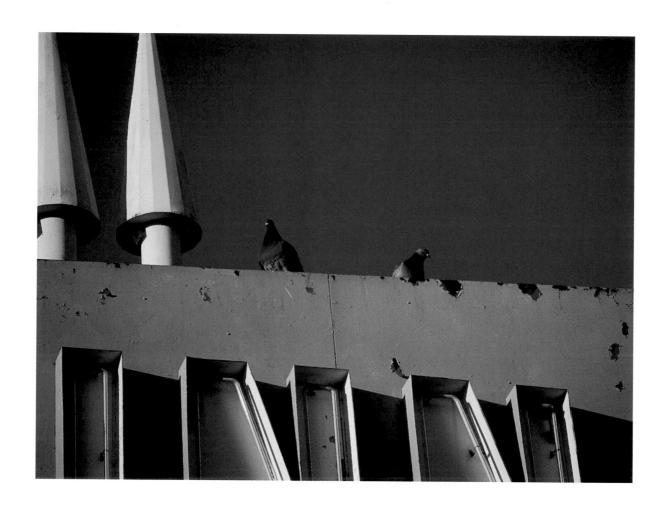

plate 2

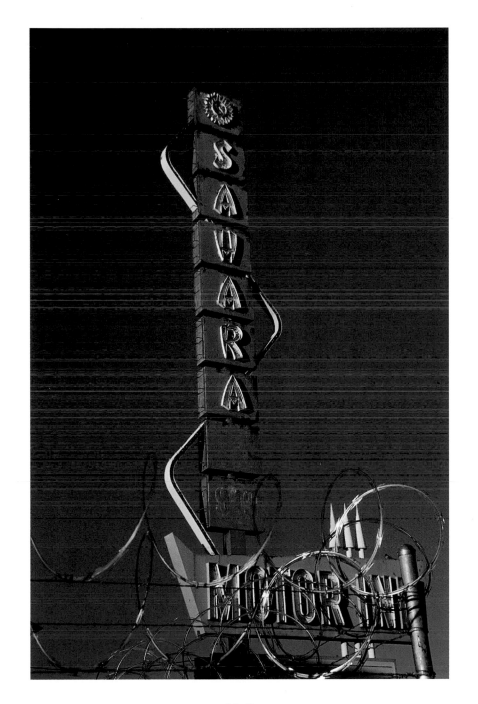

plate 3

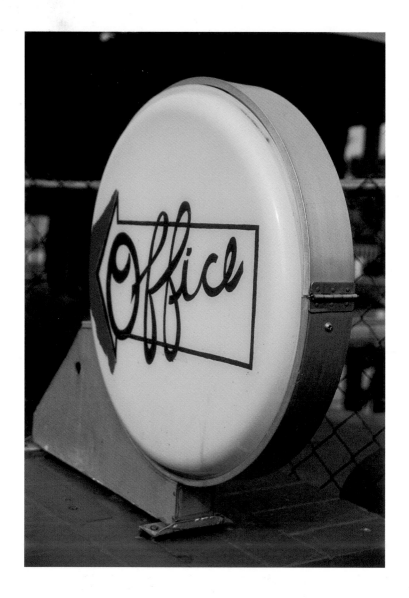

plate 4

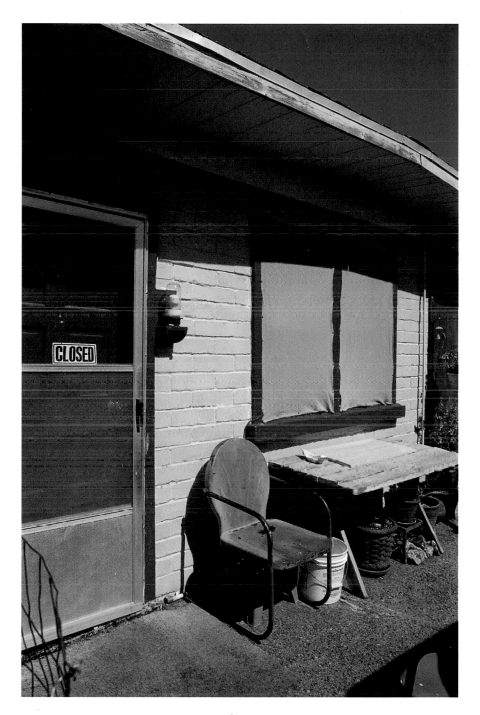

plate 5

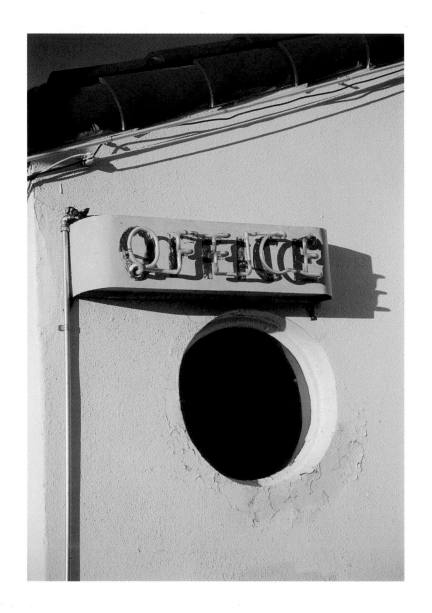

plate 6

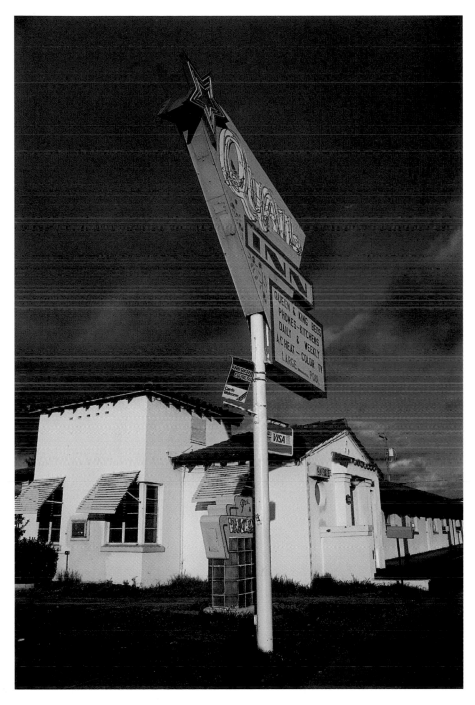

plate 7

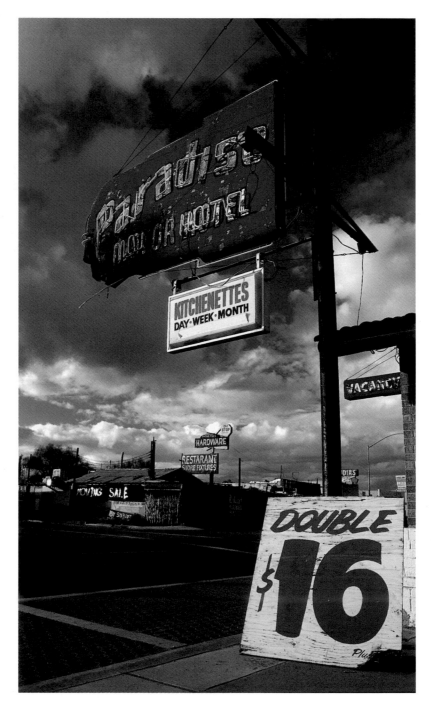

plate 8

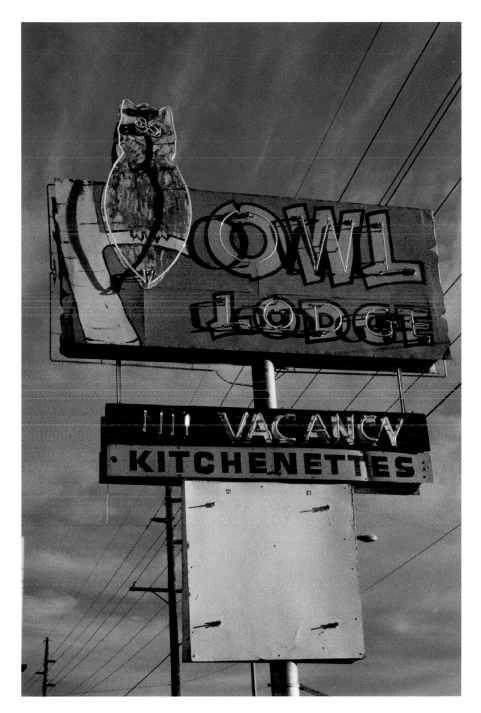

plate 9

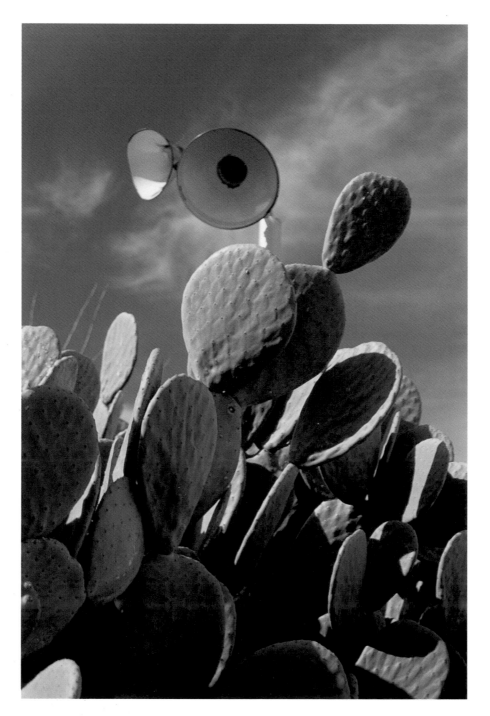

plate 12

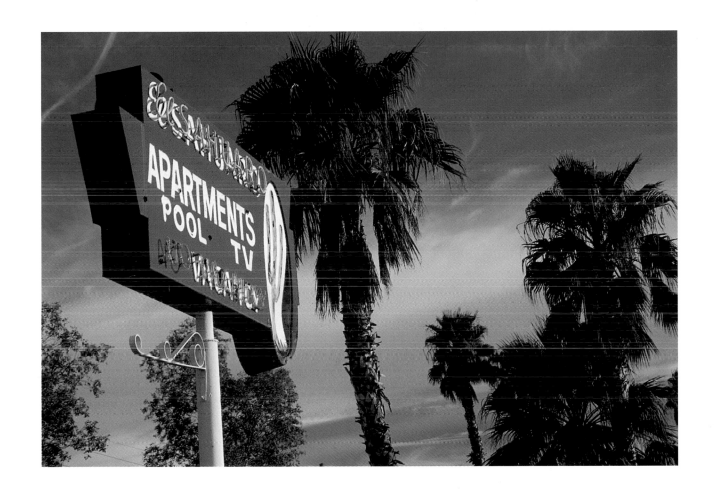

plate 13

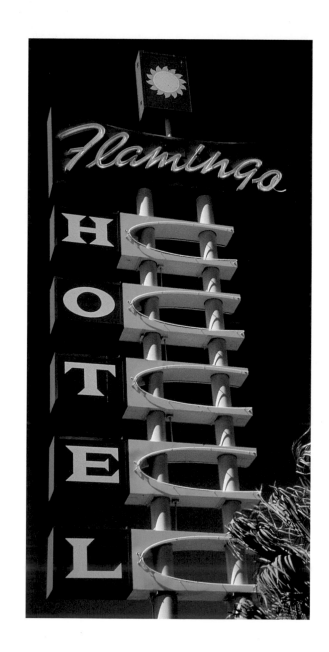

plate 14

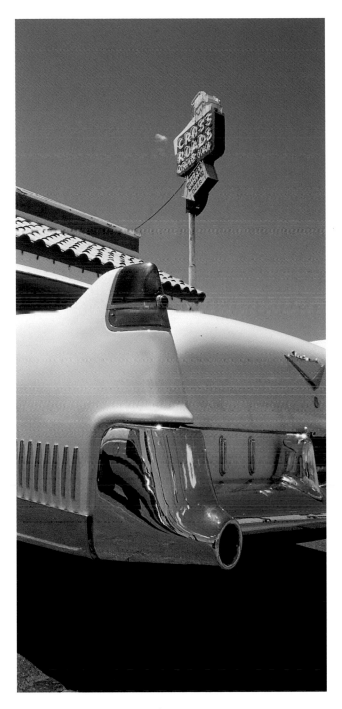

plate 15

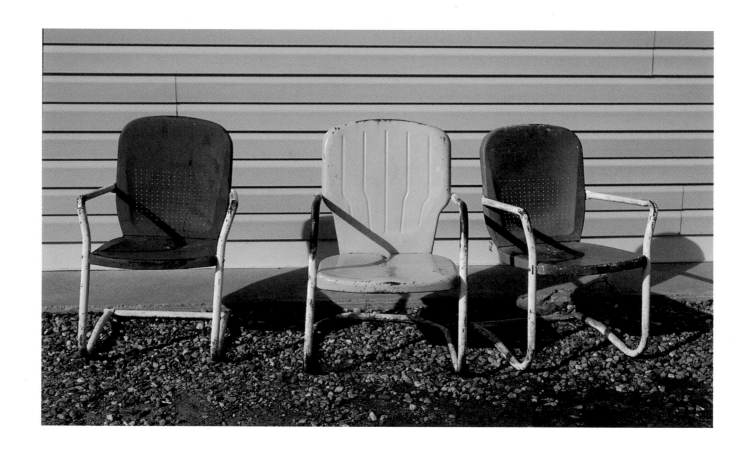

plate 16

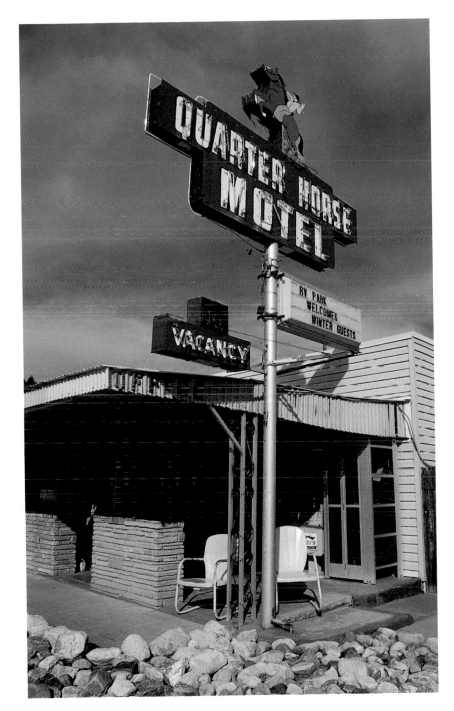

plate 17

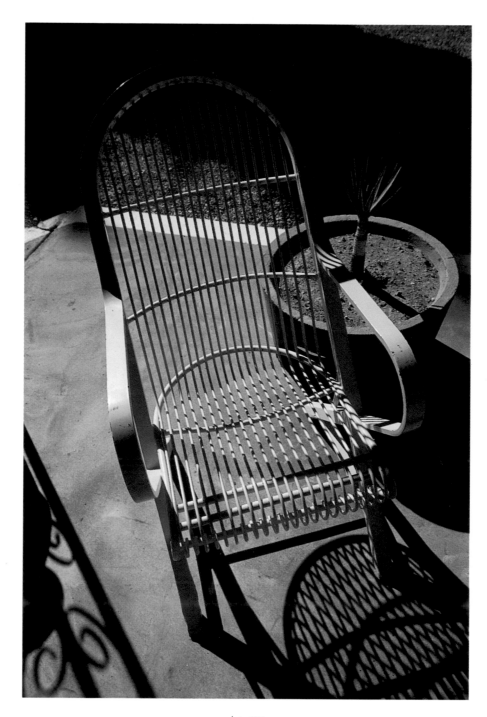

plate 20

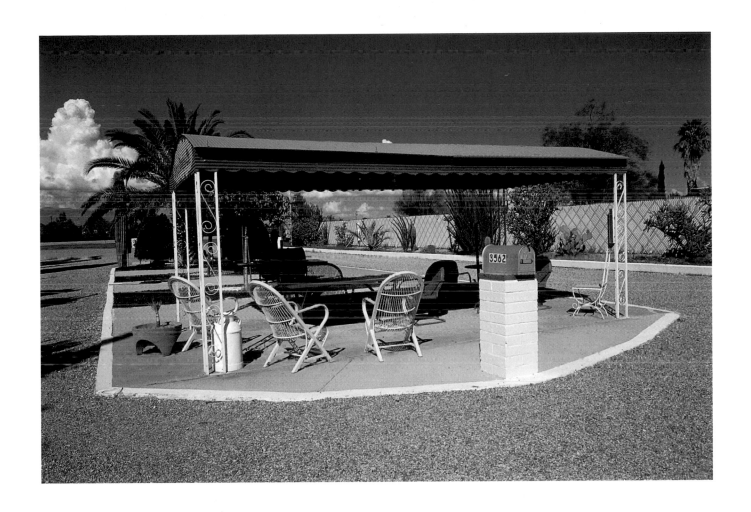

plate 21

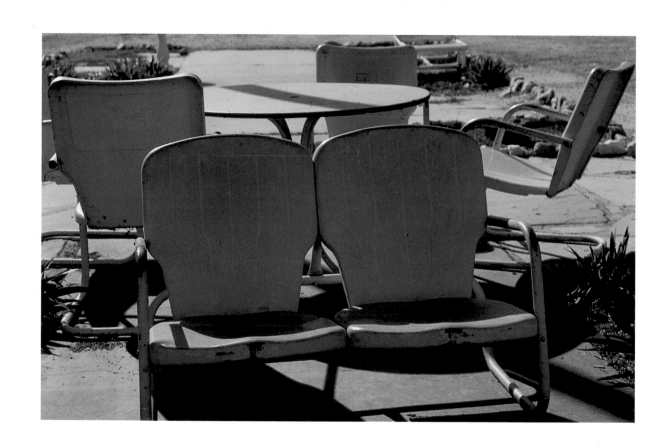

plate 24

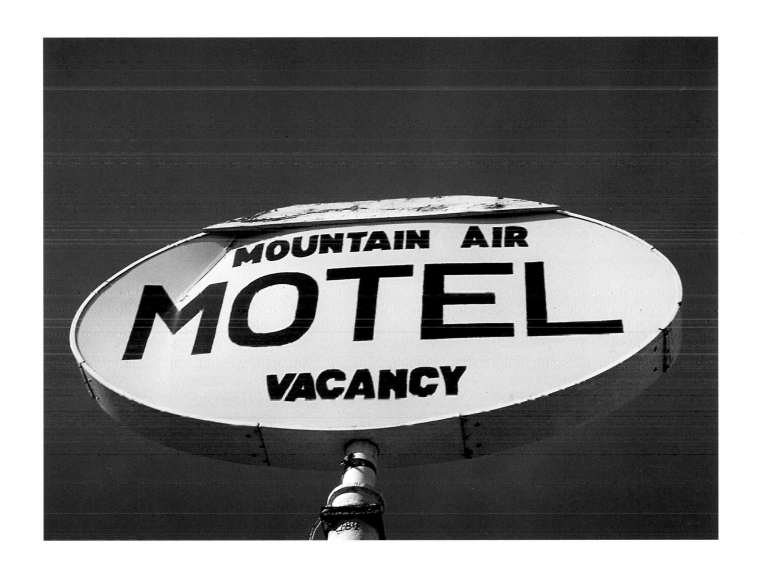

plate 25

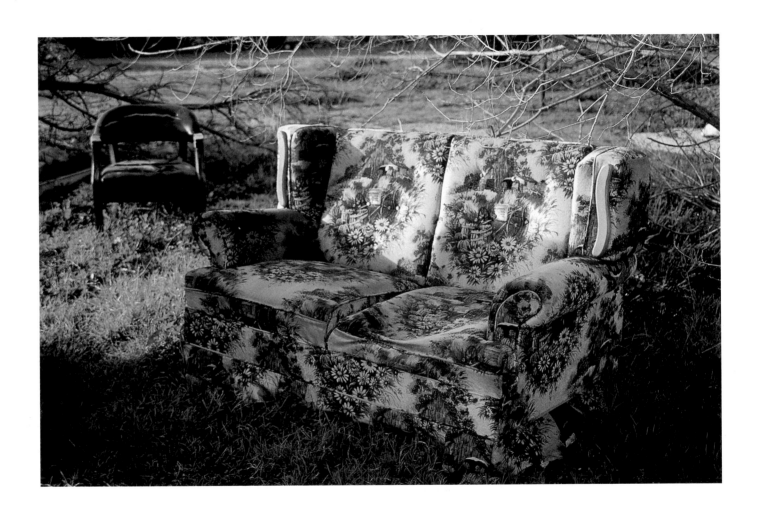

plate 32

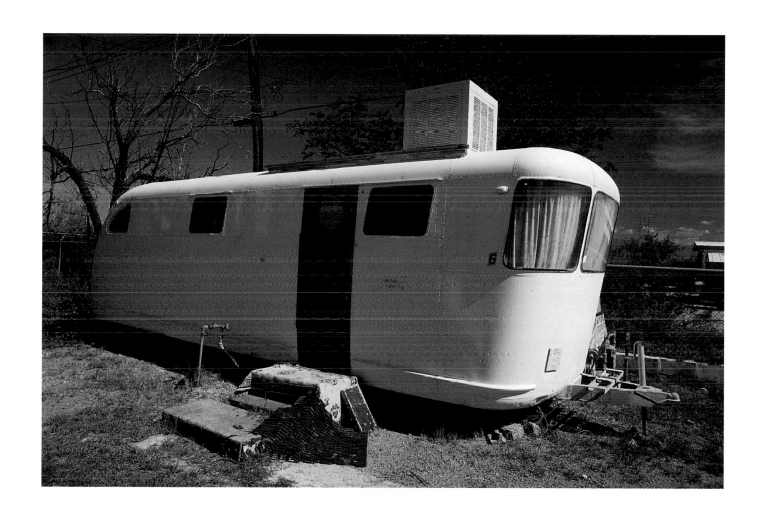

plate 33

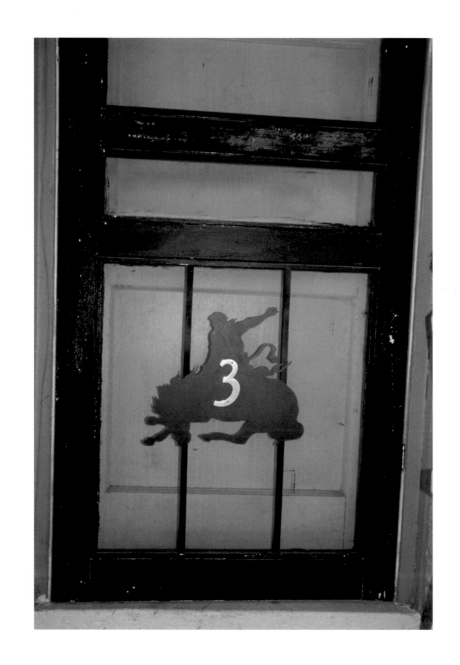

plate 34

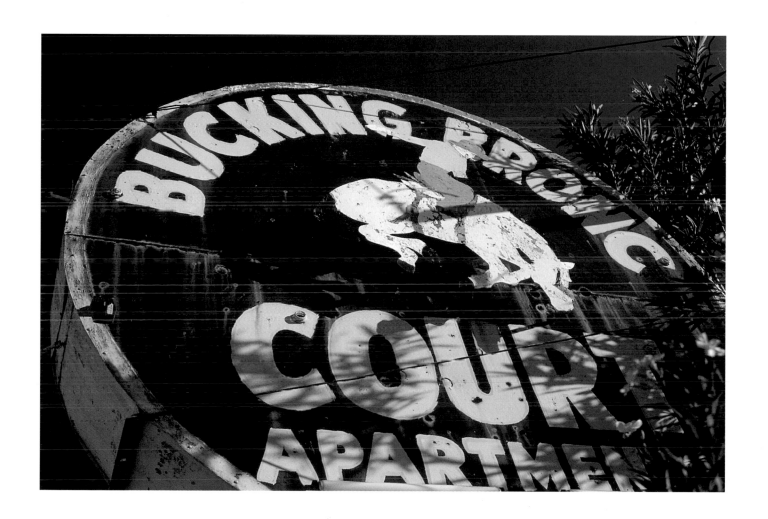

plate 35

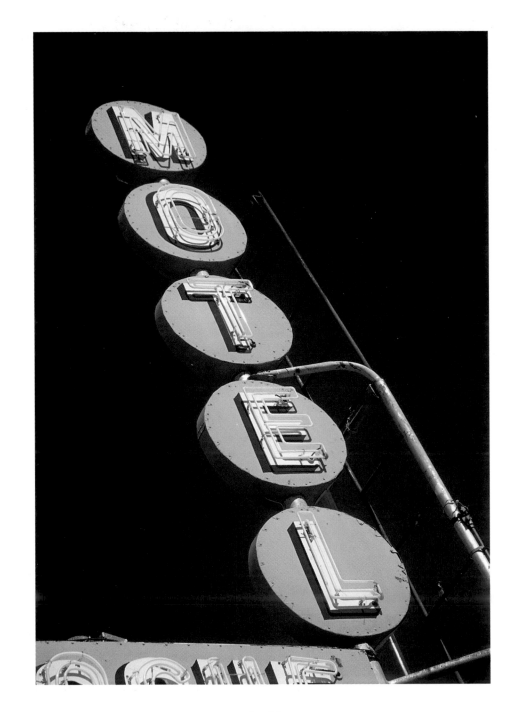

plate 36

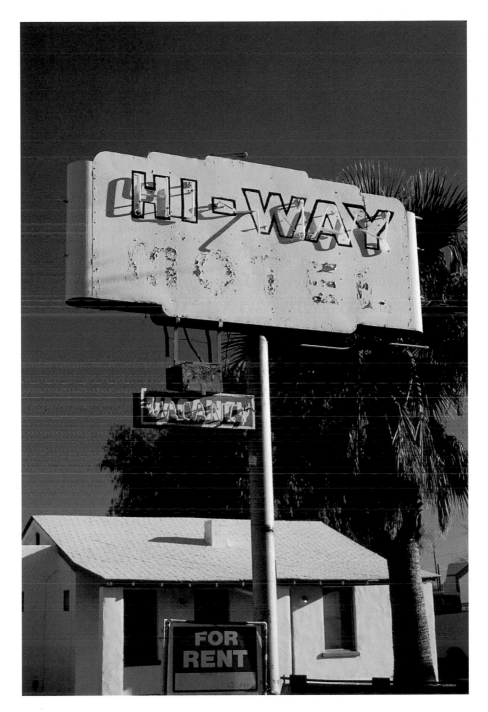

plate 37

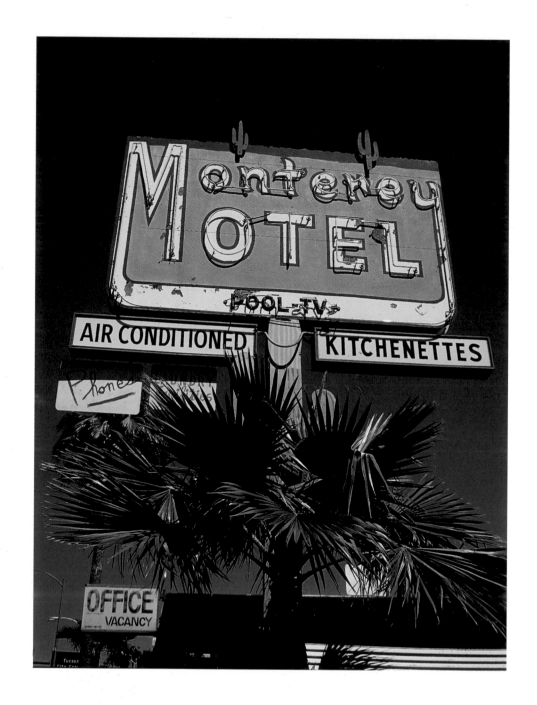

plate 38

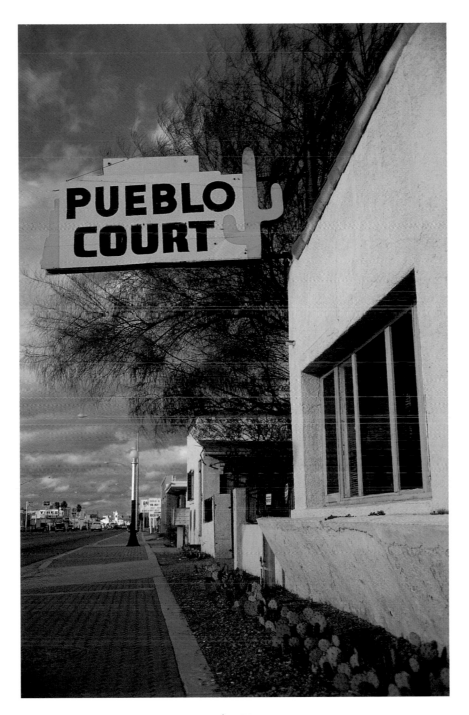

plate 39

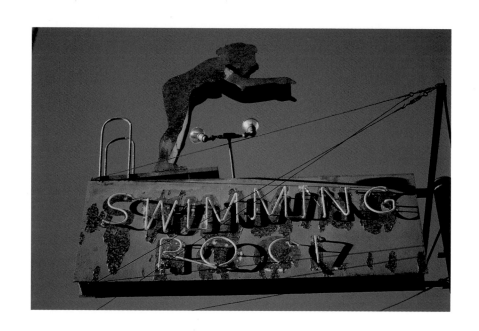

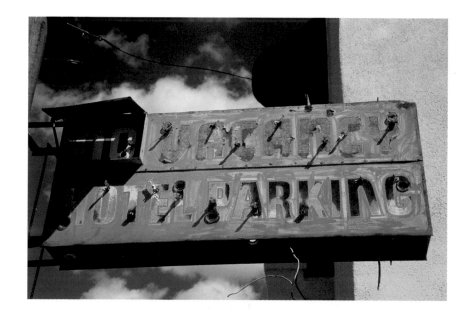

plate 40

plate 41

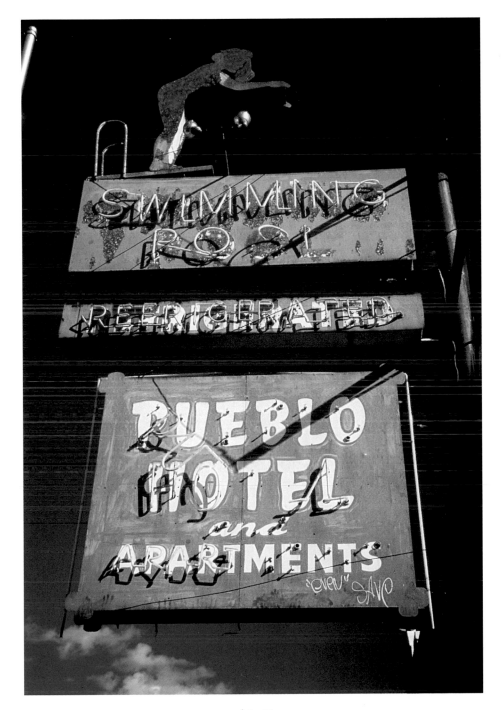

plate 42

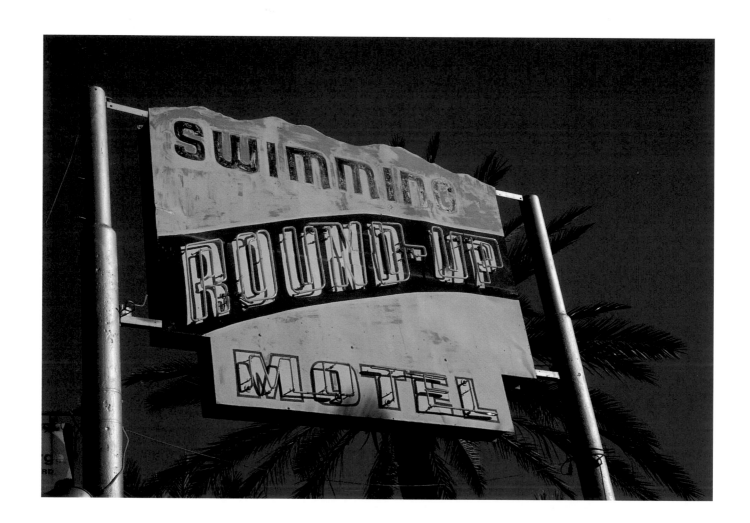

plate 43

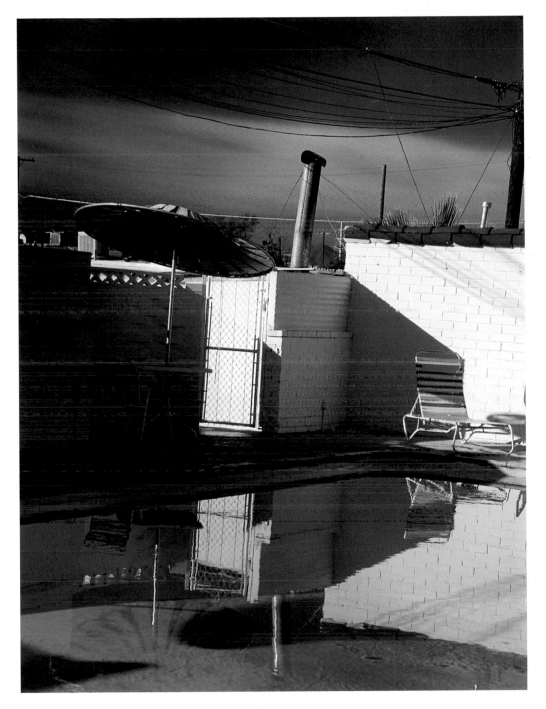

plate 44

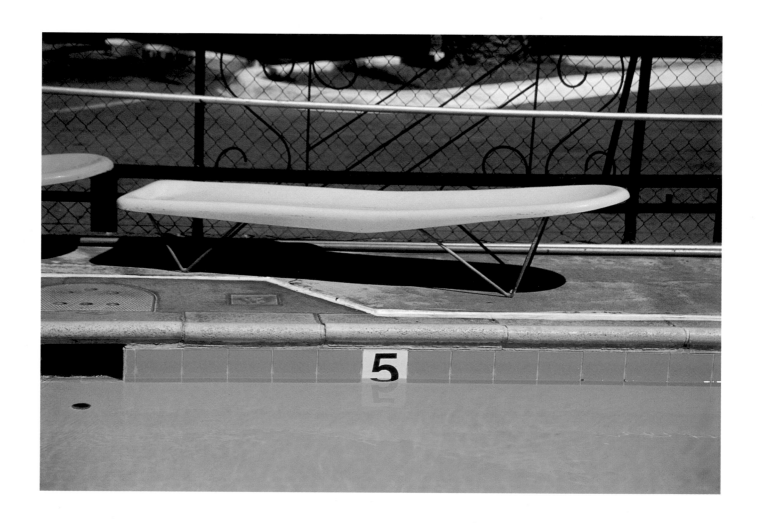

plate 45

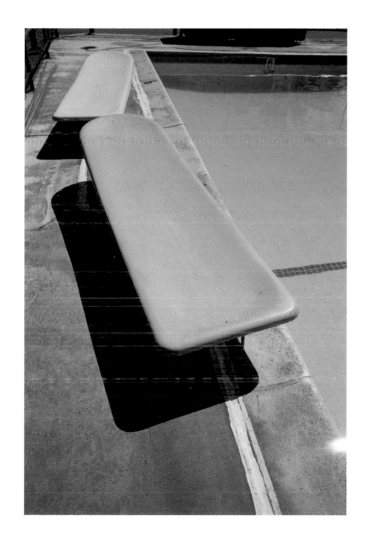

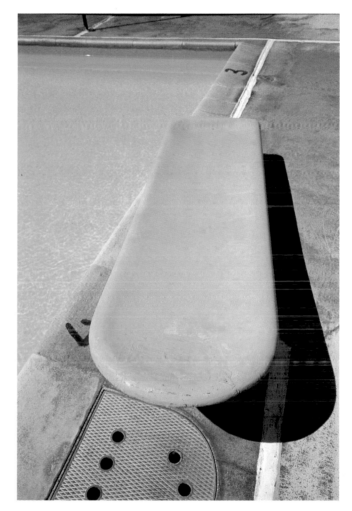

plate 46

plate 47

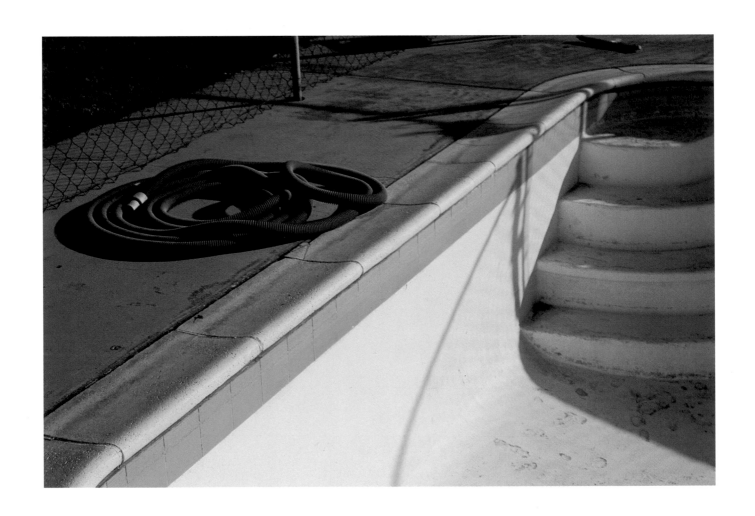

plate 50

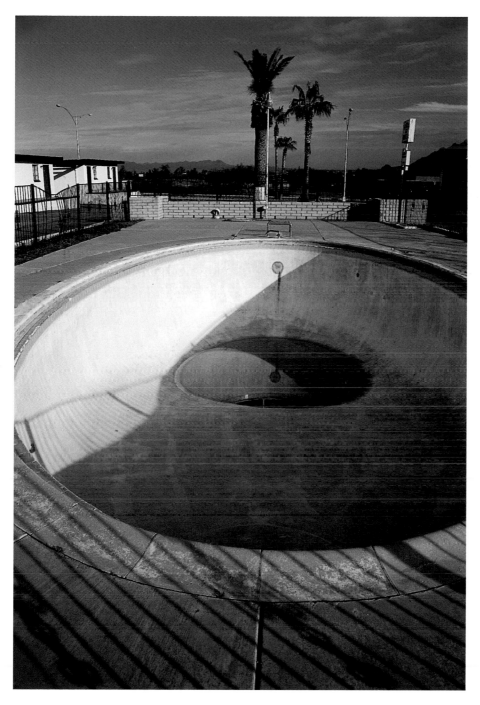

plate 51

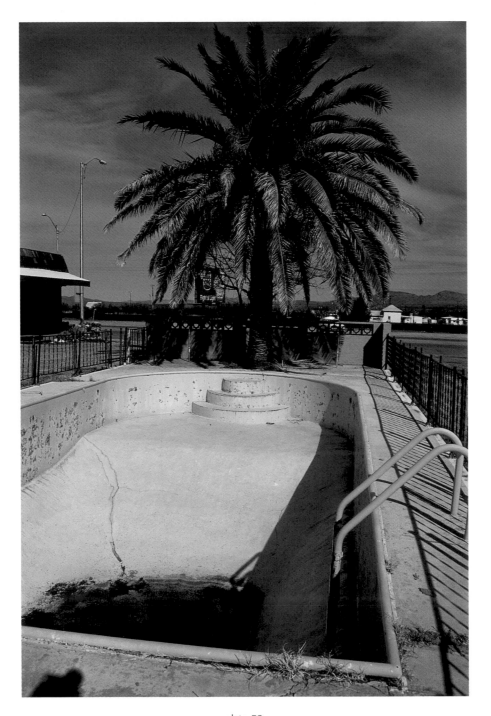

plate 52

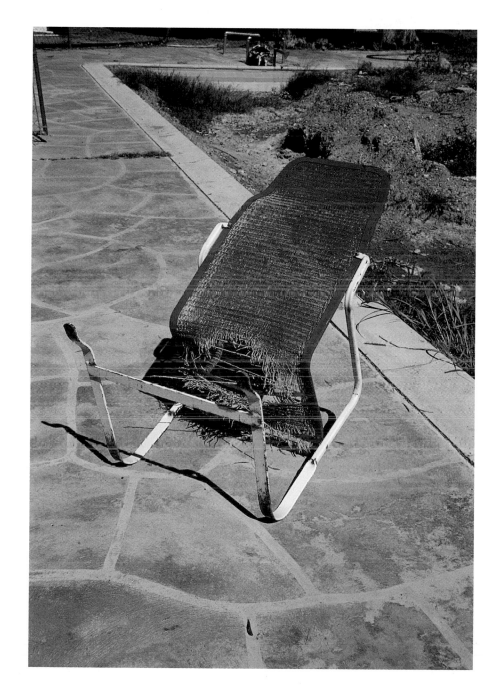

plate 53

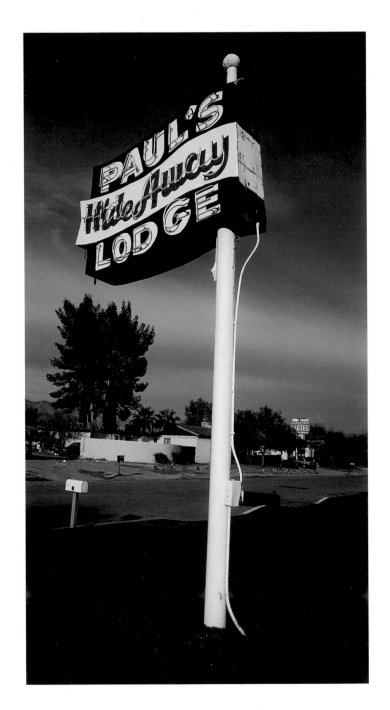

plate 54

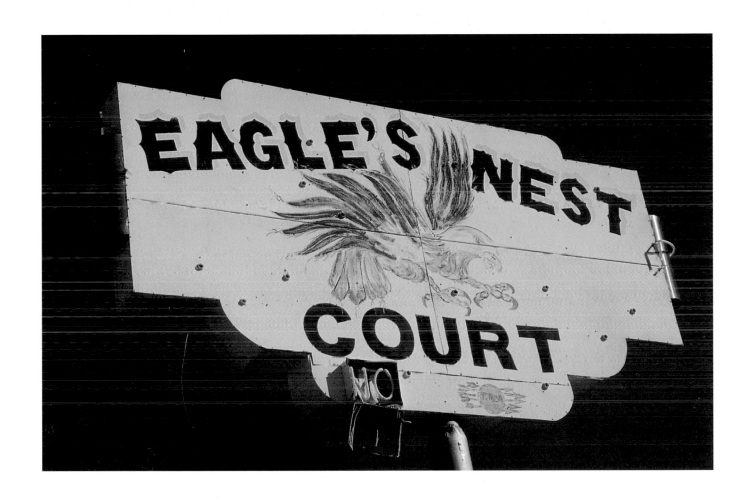

plate 55

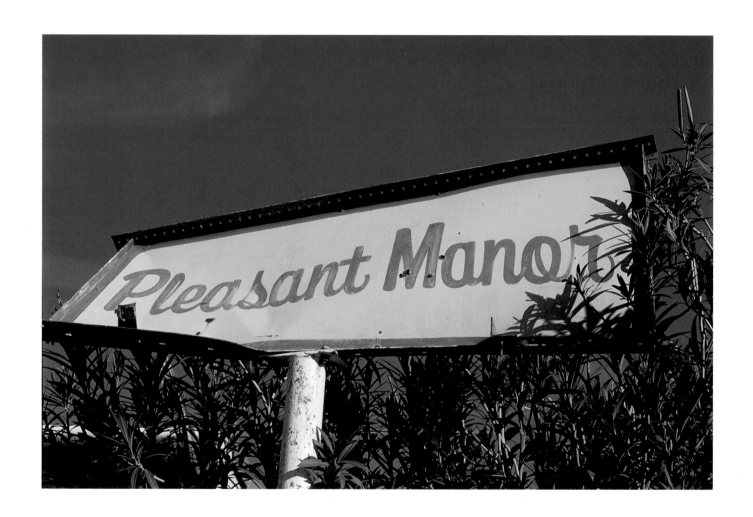

plate 56

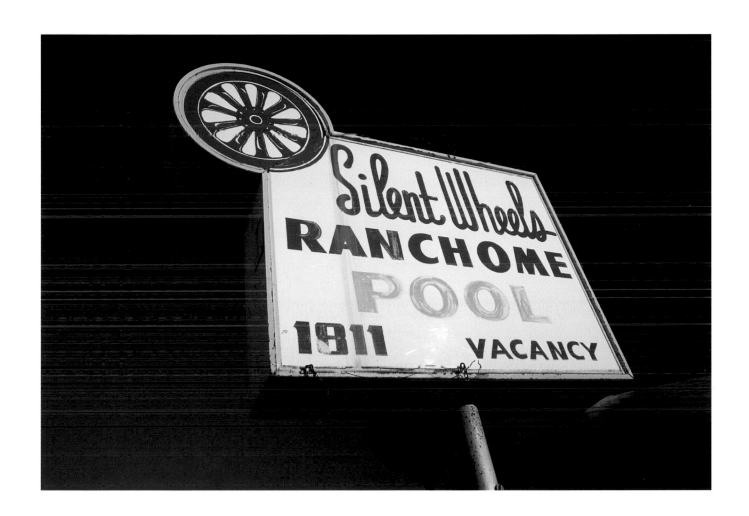

plate 57

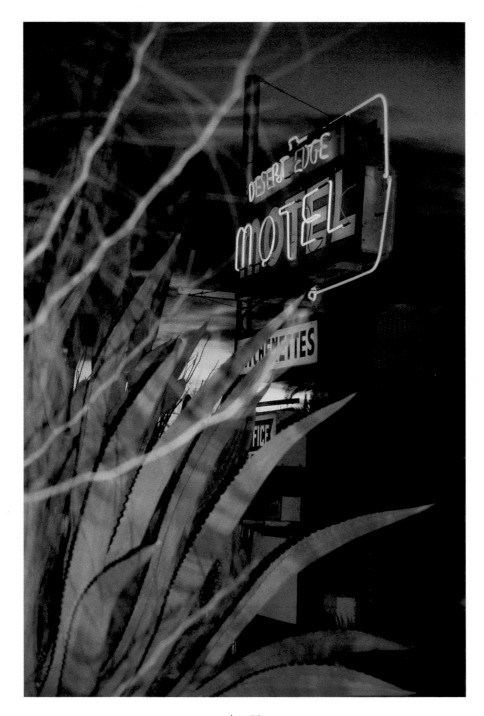

plate 58

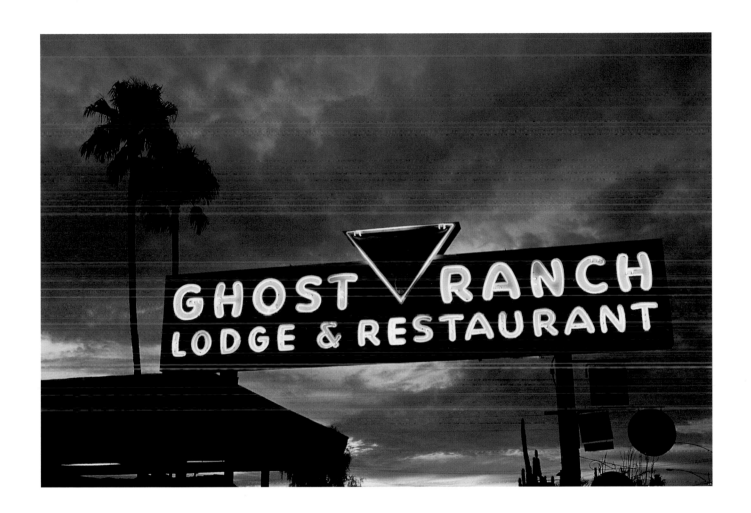

plate 59

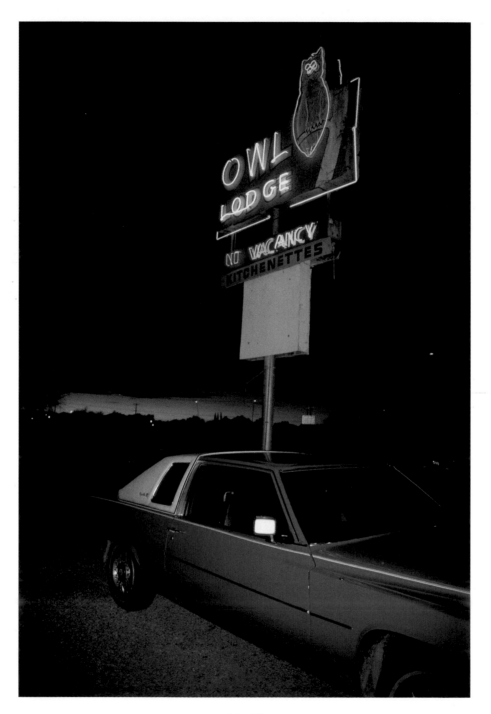

plate 60

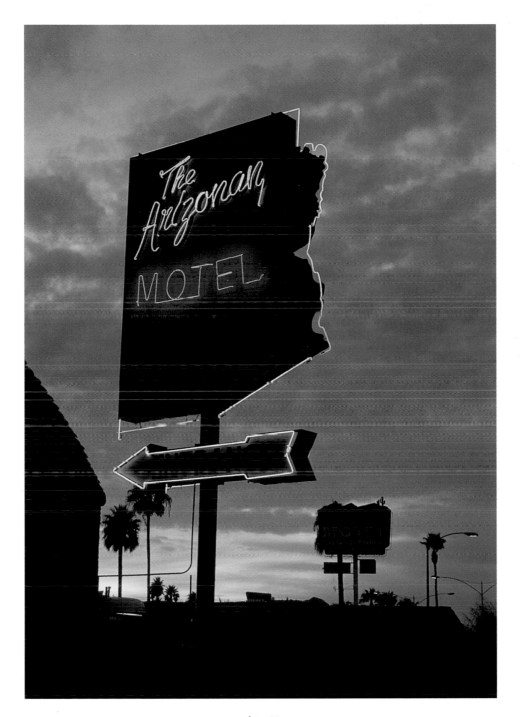

plate 61

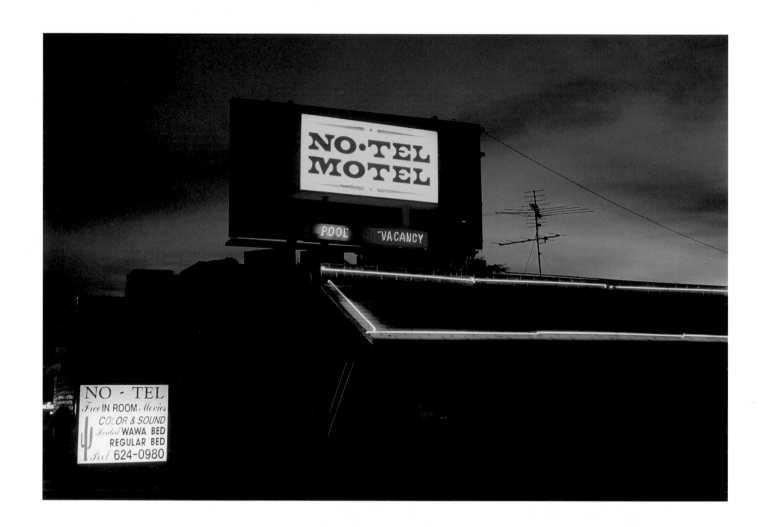

plate 62

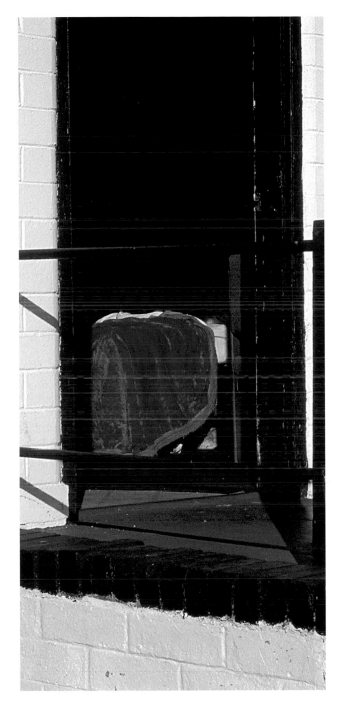

plate 63

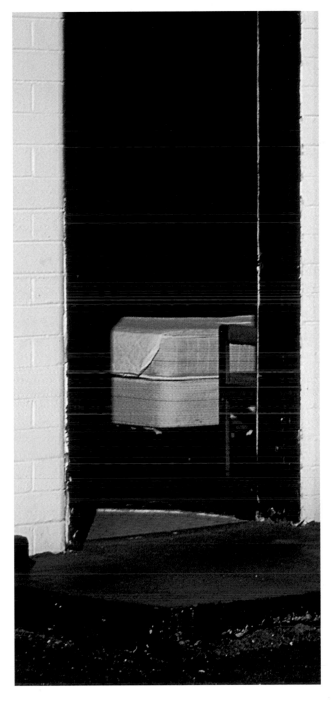

plate 64

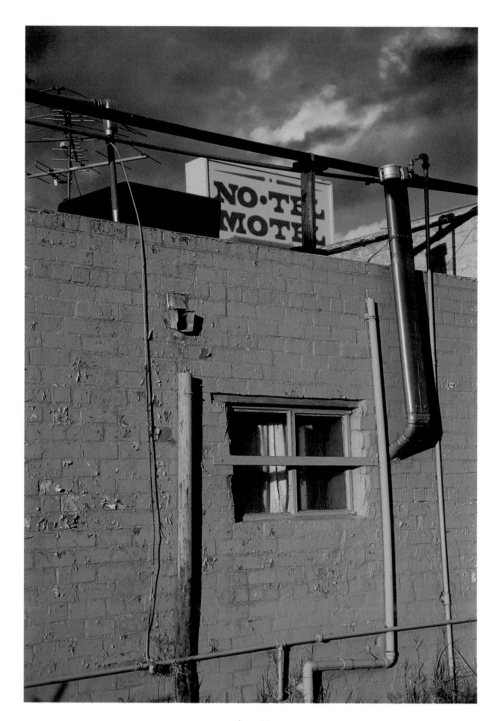

plate 65

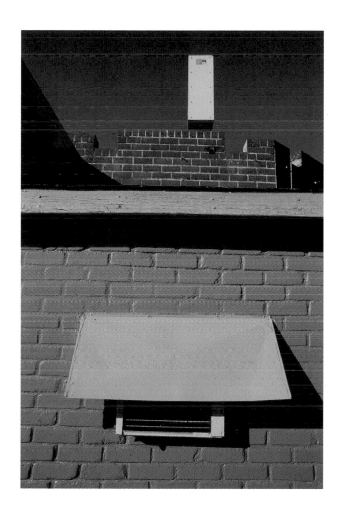

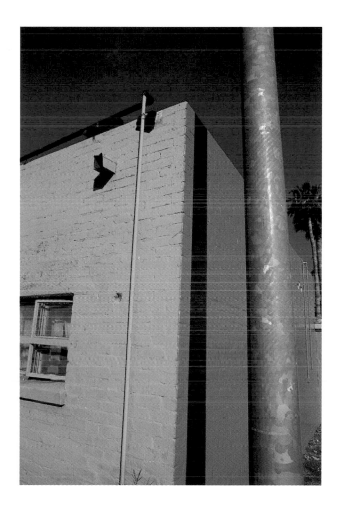

plate 66
plate 67

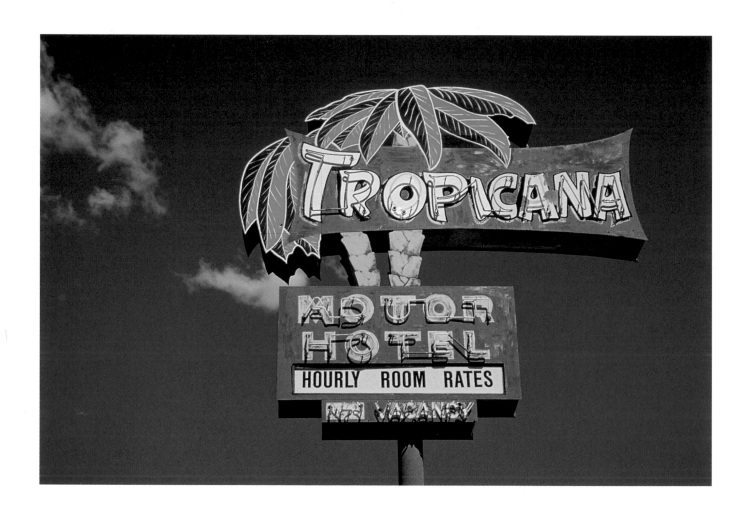

plate 68

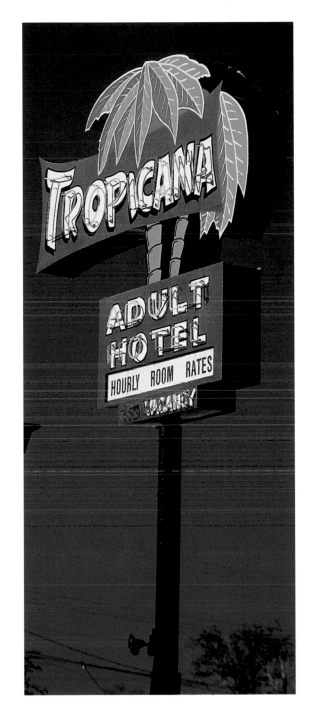

plate 69

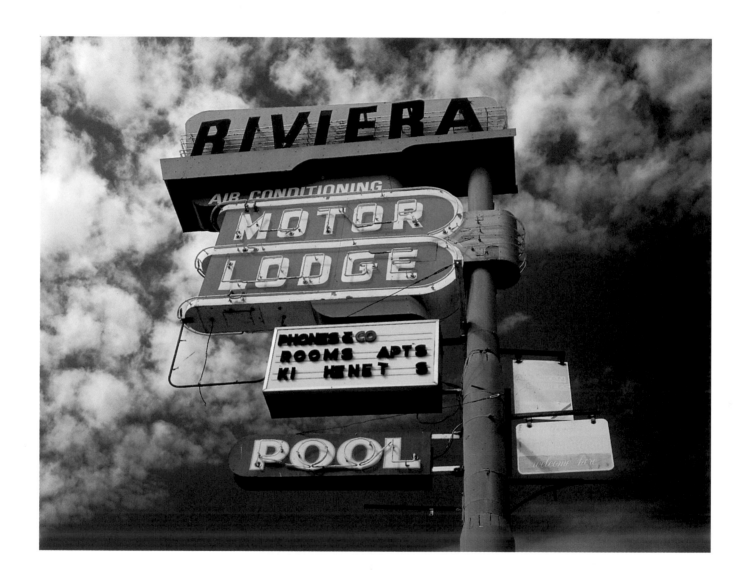

plate 70

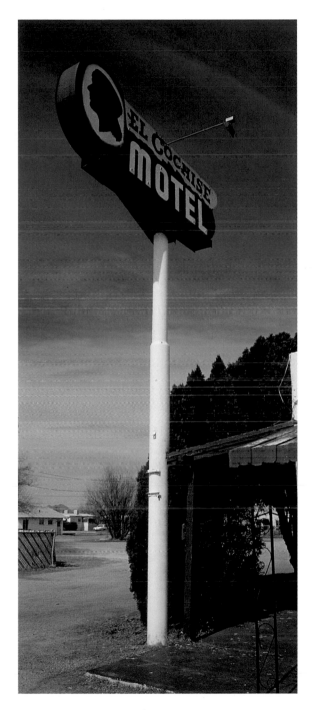

plate 71

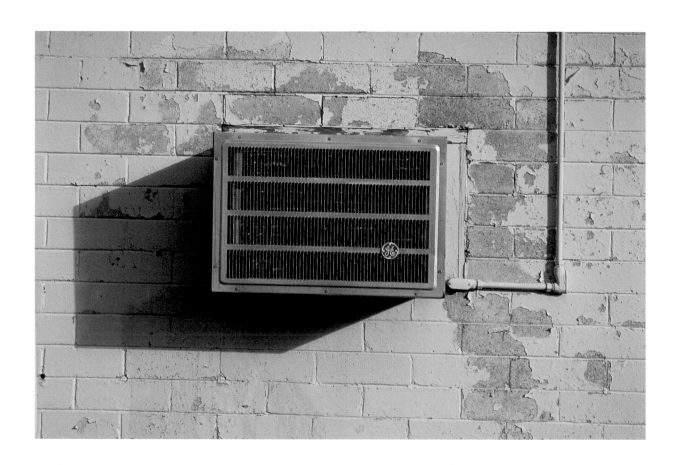

plate 72

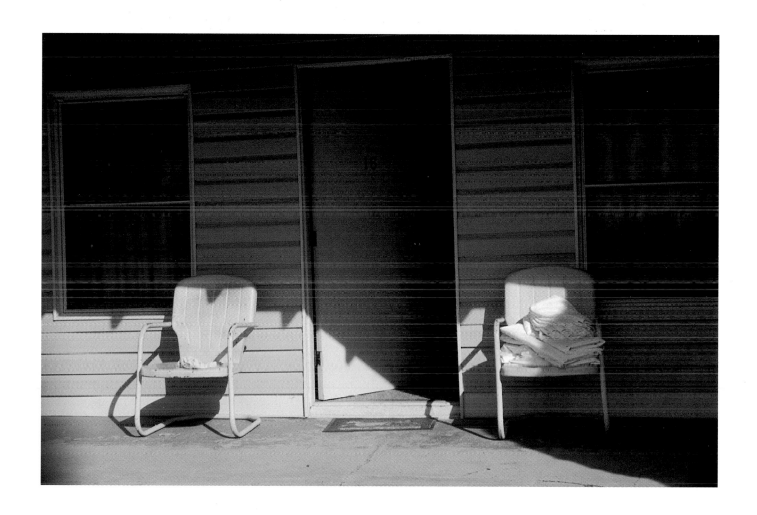

plate 73

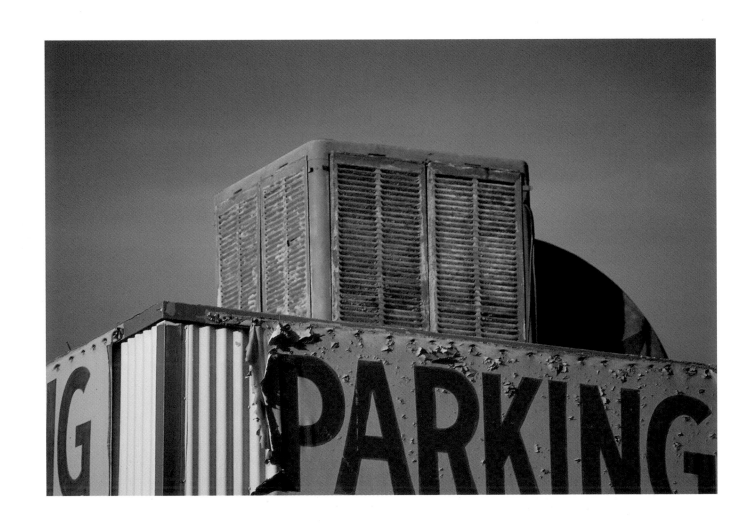

plate 74

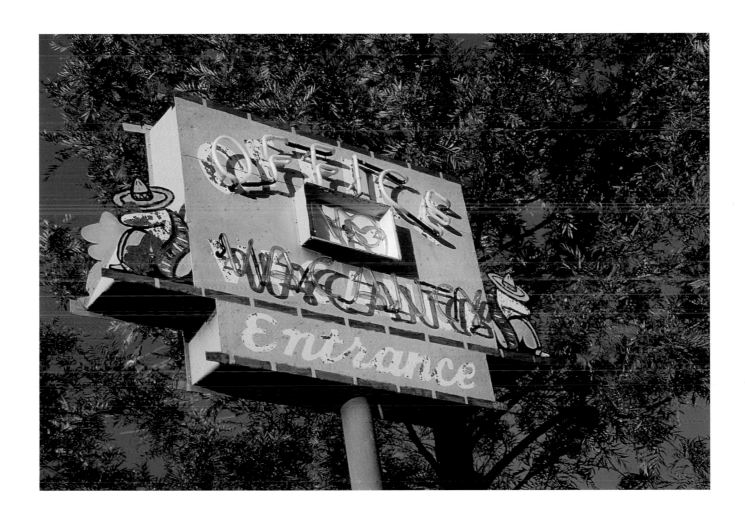

plate 75

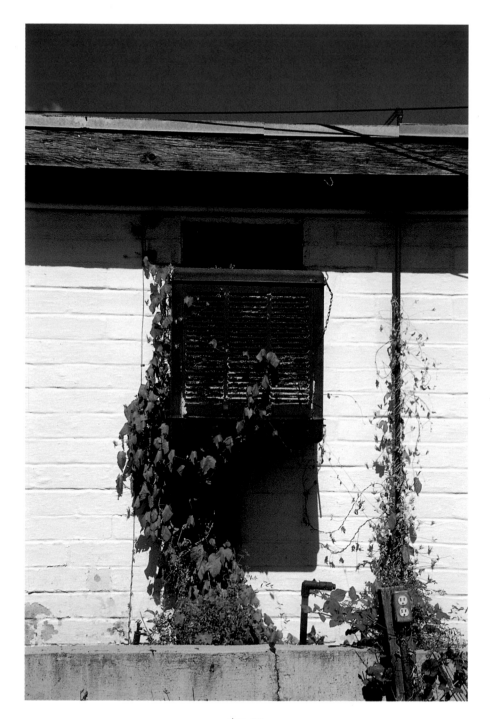

plate 76

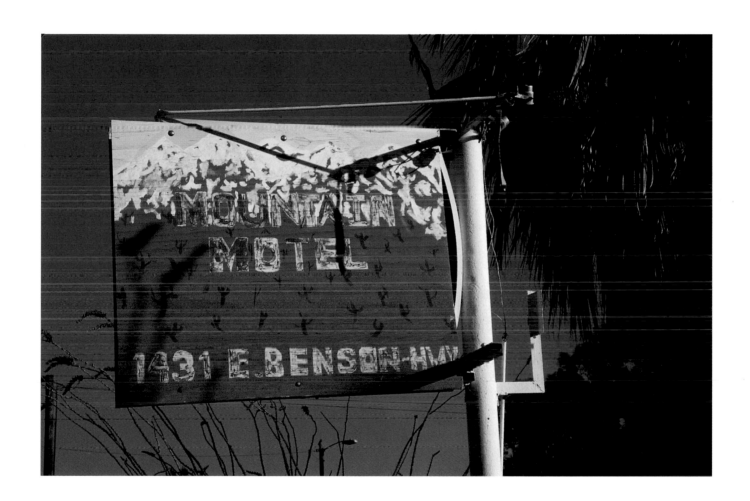

plate 77

plate 78

plate 79

to jail if you weren't "dressed Western" (which Abigail remembers as a frightening childhood experience). Tucson was also one of the gateways for trips into Mexico or short junkets to Nogales to bring back exotic or tacky (depending on your taste) decorations for the home; lots of cheap booze (a gallon a person, no age limitation, cross the border multiple times in the same day if you were gutsy); easily procured hard drugs; and, for a few pesos, unentangled sex.

The two interstate highways that encircle and bypass Tucson brought with them chain restaurants and motels that spread like locusts. We sensed a profound loss of the originality and adventure which travel once promised. On the interstates everything— restaurants, motels, gas stations and rest stops—seems to look, taste, feel and smell the same. Even the signage has become standardized so that no matter where you go, you're always in the same place.

We felt a sense of urgency validated by the disappearance of two fabulous signs we scouted on one of our earliest shoots. The signs, a huge three-dimensional saguaro cactus at the Tucson Greyhound Park Motel, and another at a politically incorrect Navajo Lodge, were excitedly discovered at sunset when we had used all our film. Returning the next morning with fresh film, eager to capture the images, we found no clues that the signs had ever existed. We realized we were pursuing a dying species. Pieces of signage and decor can now be sighted in upscale shops and collections, often carrying outrageous price tags, testifying to a newfound nostalgic appeal for the styles of the old automobile days.

We found many of the old motels condemned, often providing a partial solution to Tucson's homeless problem. Shooting sites at night was always frightening: we suspected that some motels were venues for drug traffickers, petty criminals and illicit rendezvous. We accidentally captured on film the transformation of a "Motor" Hotel into an "Adult" Hotel with "hourly rates" as the old neon sign was refurbished.

Another group of motels limps along like decrepit old citizens, sometimes displaying hopeful "For Sale" signs displayed near the despondent "Vacancy." Although "$16 Double" is only a memory, such

motels may still provide economical rest-stops. However, several owners told us that their properties were often filled for months at a time by working people for whom motels provided their only affordable housing. Many have absentee owners who live as far away as Hong Kong. These seem to be run by resident managers who worried about photographic intrusions perhaps thinking that we really worked for the Health Department. By contrast to the pride expressed by the owners with whom we spoke, most managers had no idea why anyone would label their workplaces (as they no doubt thought of them) artistically interesting. Frequently cleaned up with cheap paint jobs (further disappointment to a photographer returning to capture an aged image on film), a few of the old motels might survive, for a while, if they are fortunate enough to be off the development path. In the long run, though, the promise of The Paradise Lodge will become Paradise Lost, as the beautiful old motels disappear into our neon memory sunset.

All the Vacant Eden images were shot on Fuji Velvia and Provia professional film. Carol used a Nikon FM2, while Abigail worked with a Minolta 7XI and 700SI.

PHOTO CREDITS
CAROL HAYDEN
Page 2 Plates 9, 10, 12, 16, 22, 24, 25, 26, 30, 31, 32, 35, 37, 50, 56, 59, 61, 62, 63, 64, 66, 67, 72, 73, 79

ABIGAIL GUMBINER
Cover, Inside Title, Pages 1, 3, 4, 5, 6 Plates 1, 2, 3, 4, 5, 6, 7, 8, 11, 13, 14, 15, 17, 18, 19, 20, 21, 23, 27, 28, 29, 33, 34, 36, 38, 39, 40, 41, 42, 43, 44, 45, 46, 47, 48, 49, 51, 52, 53, 54, 55, 57, 58, 60, 65, 68, 69, 70, 71, 74, 75, 76, 77, 78, 80

ACKNOWLEDGMENTS
We would like to thank Frances Bernfeld for her friendship and hospitality in Tucson, our creative publisher, Ann Gray, our agent, Martha Kaplan of New York, Peter Shamray of Navigator Press, Pasadena, our lawyer M.J. Bogatin of San Francisco, Dan Cassal of Copies Now, Pasadena and photojournalist David Wells and Peggy and Yoram Kahana of Shooting Star, Los Angeles for inspiration. Abigail thanks her husband David Hitlin and daughter Tamar Halpern for their persistent support, her friend Elizabeth Bloom, and lithographer Peter Holmes. Carol is grateful to her husband Fred and their children Roxanne Shelly and Ramon Hayden for limitless enthusiasm and encouragement, and her mentor Dorothy Mayers, and the Image Circle Photographers for stimulation and nourishment of creativity.

Abigail Gumbiner

Carol Hayden

Jim Heimann is a graphic designer and author of *California Crazy: Roadside Vernacular Architecture, Out With the Stars, Close Cover Before Striking, Car Hops and Curb Service,* and *Hurray for Hollywood.*

Abigail Gumbiner is a photographer and metal sculptor whose work is installed at Shidoni, New Mexico, and in several galleries in the West. Carol Hayden is an outdoor photographer, historian and computer software developer. Together they formed CatchLight Photography and have sold and shown their work in many galleries, corporate and private venues.